THE
Wing Reader

THE
Wing Reader

An Illustrated Poem

By Brooke Smith

Illustrated by Brian Rea

Library of Congress Cataloging-in-Publication Data

Names: Smith, Brooke, 1961- author. | Rea, Brian, illustrator.
Title: The wing reader : an illustrated poem / by Brooke Smith ;
illustrated by Brian Rea.
Description: San Francisco : Chronicle Books, [2018]
Identifiers: LCCN 2017004674 | ISBN 9781452158761 (alk. paper)
Classification: LCC PS3619.M55386 W56 2018 | DDC 811/.6—dc23
LC record available at https://lccn.loc.gov/2017004674

Manufactured in China.

Design by Jennifer Tolo Pirce

10 9 8 7 6 5 4 3 2 1

Chronicle books and gifts are available at special quantity
discounts to corporations, professional associations, literacy
programs, and other organizations. For details and discount
information, please contact our premiums department at
corporatesales@chroniclebooks.com or at 1-800-759-0190.

Chronicle Books LLC
680 Second Street
San Francisco, California 94107
www.chroniclebooks.com

To Dad.
Who wouldn't let me stop believing.

And Kelly,
and Mimi.

You are all so loved.

She decided she needed a place
to rest, and walked out
into the meadow.

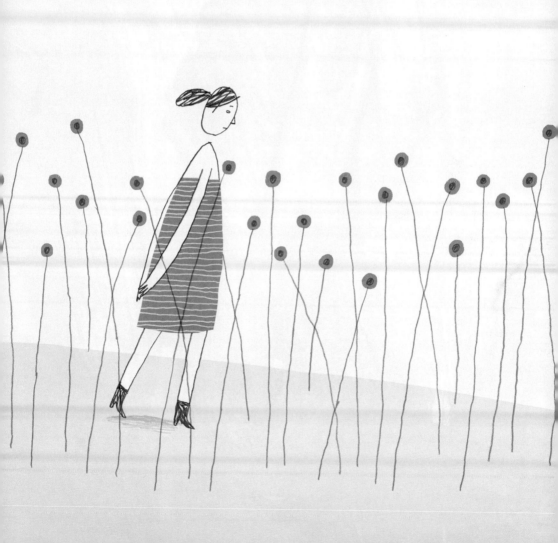

One,
two,
three
holes torn in a heart
that had seen
better days.

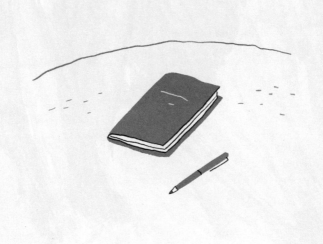

She came for light.
She came to write.
(how we hope to understand her)

Heavy air a fragrant potion
willing her to breathe.

Tall grasses, brilliant, bending
soft breeze
she fell to her knees.

Too tired to walk too far to recover,
to look
or search
anymore.

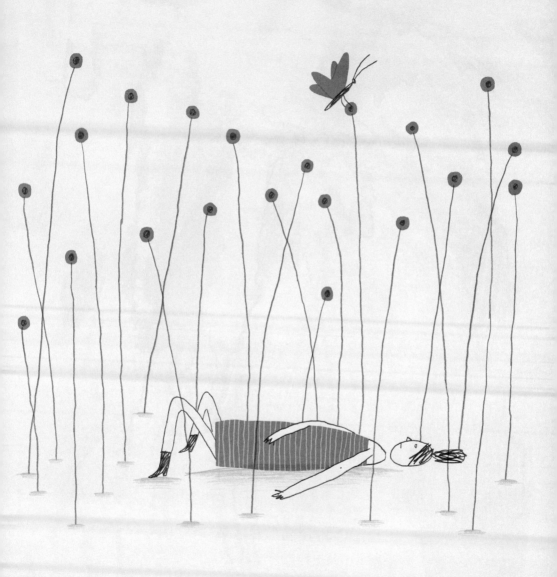

(what can you see when you let yourself be?)

She sat still.

Watched
as a butterfly
landed on a reed
jutting over her head.

Markings, of purple and
turquoise and gold.
Nature's etchings had always amazed her.

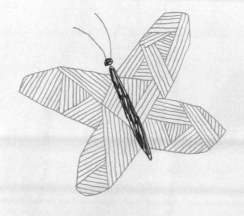

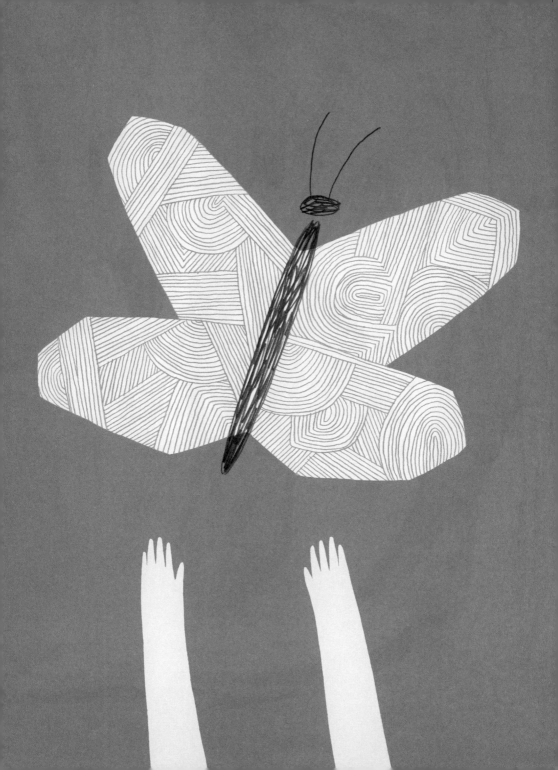

On the wings were faint lines
curved, bent and crooked.

They looked like letters.
And then, became words.

She read each one quickly.
(they could all disappear)

Without pausing.
Not pausing out of fear.

BLUE
SKY
GOODBYE

Wait.

Words are not
cannot
be written on wings.

(no one would believe her)

Impossible. Not possible.
Look away.

But words are just letters and
letters are just lines.
Lines and shapes
that have meaning.

Maybe words have always been
flying above
but no one has seen them
or been in awe of.

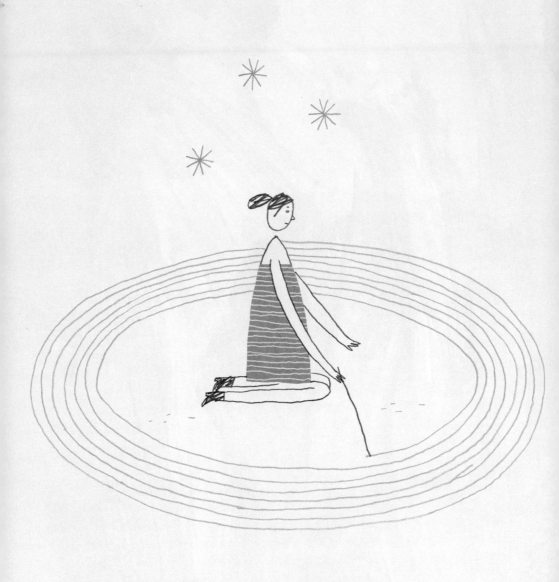

Mix seeing and believing.
(one broken heart chose to believe)

Alchemy done.

Story spun.

To remember
Love.

She began . . .

A boy ran into
his uncle's arms,
like he'd done since
he was five.

Lifted up, lifted high.
Pretending, he could fly.

The boy loved to kiss the ceiling.
(loved to kiss the SKY)

Up among the clouds
endless BLUE,
where they never had to say
GOODBYE.

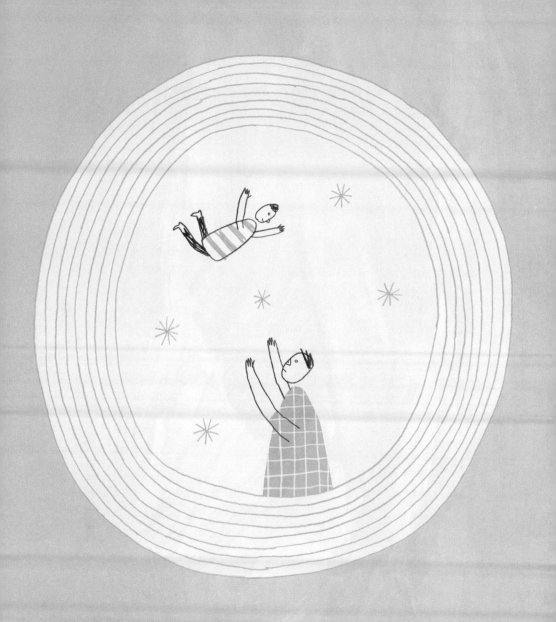

Story told
moment captured
the butterfly flew away.

Make no mistake, these were not her words.
So beautiful she could never
claim them.

A sacred moment told through her, not by her.
Deep love was what she could see.

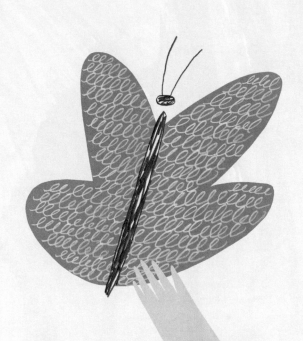

Then another landed on her hand.

(anticipation when fear recedes)

It no longer mattered
she no longer cared, if anyone else
believed.

(look closely)

PHOEBE
SINGS
SUNDAY

And she began . . .

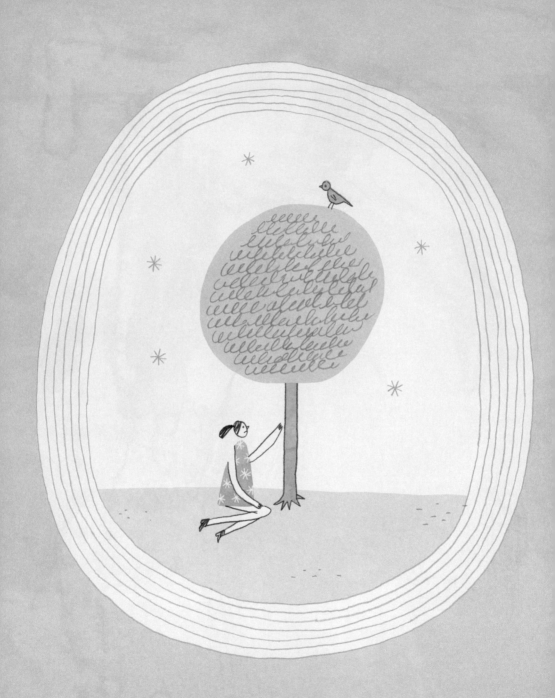

Her grandmother's name
was PHOEBE.
Named after a tiny bird.

Every SUNDAY she went
to her grandmother's house,
a place of only kind words.

(safekeeping)

Her grandmother
would tell her, that every time
a phoebe SINGS,
she should close her eyes and listen

"And you'll see me, in the trees."

That one flew away, and another beckoned.
Soothing words arrived
(look inside)

RAIN
WATER
SILENCE

And she began . . .

The RAIN came
cascading down, as she
sat on a curb
while it poured.

Her bare feet rested
in the cold, running WATER.
She could not be ignored.

(spellbound)

He walked over
and asked her
if everything was alright.

She answered him with SILENCE
and he knew,
it was love at
first sight.

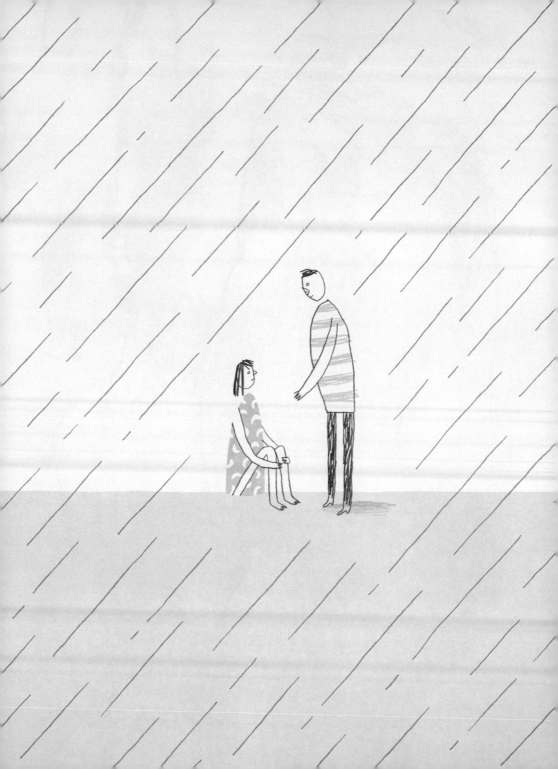

Then from far off,
another fluttered.
Soft landing, tender words.

TEARS
VELVET
SUNLIGHT

She came to write.
(remember)

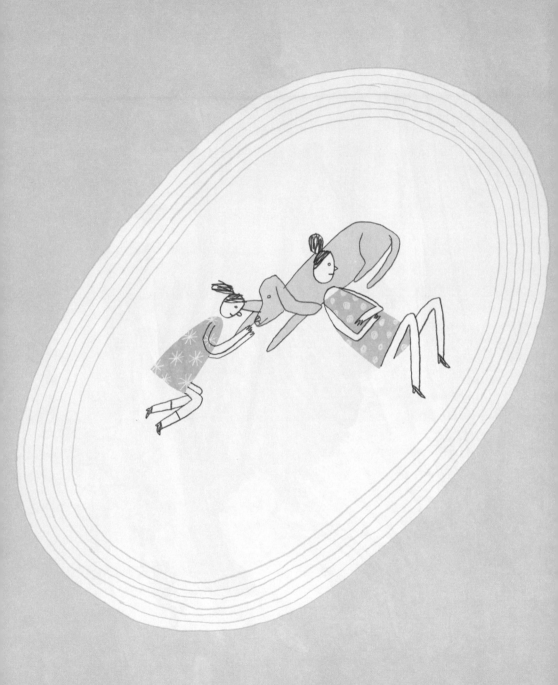

A little girl curled up
next to her dog,
whose ears were soft
as VELVET.

She told him about,
her very sad day.
Friends were mean.
No one would play.

TEARS filled her eyes,
then her mother appeared.
Lay down by her side,
and her tears disappeared.

The three of them stayed there
all afternoon.
Laughter and SUNLIGHT
filling the room.

Bearing witness.

Fragile moments,
ordinary.

Tucked inside.

You never know
where deep love hides.

(pay attention)

And then the air went still.
All gone.

But a single motion, remained.
Looked at her. Through her. Knew her.

When she read the words, she understood.
(these last words, belonged to her)

LOST
APART
COLLIDE

And *he* began . . .

I have to tell you.
I know how it will end.

It will be like it was
when we were LOST
that late afternoon in
December.

We got separated
searched in circles,
managed to
COLLIDE.

We came around a corner
found each other
and walked away, side by side.

So when we meet here after
it will be just the same.
First circling APART

(but not in our hearts)

Until we turn around said corner.
Turn around said bend.

And find ourselves walking
together, once again.

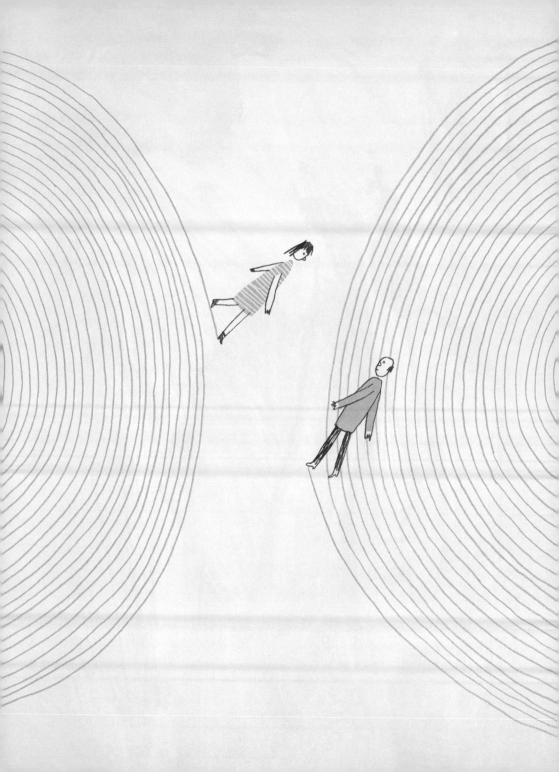

True story told.
Meaning, unfolds.

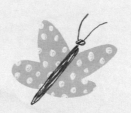

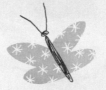

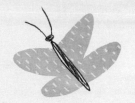

These moments were between real people.

Deep love a thread only wide eyes could see.

Tying here to there.

People lost.
Now found.

In the air
on wings
all around.

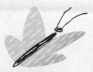

Wings are paper that can travel through time.
Words carried great distances, from another side.

Because (she said)

Love. Never. Dies.

She opened her eyes.

Lying in a meadow, in the thick
warm air, she'd been sleeping.

Awakened, by a full heart.

Awakened, from a dream.

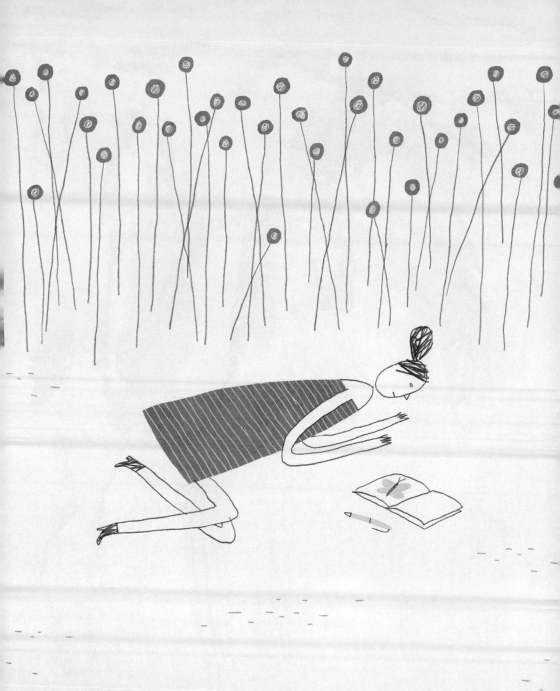

She went home and opened,
all the windows.

Suddenly, quietly
a butterfly
flew, through . . .

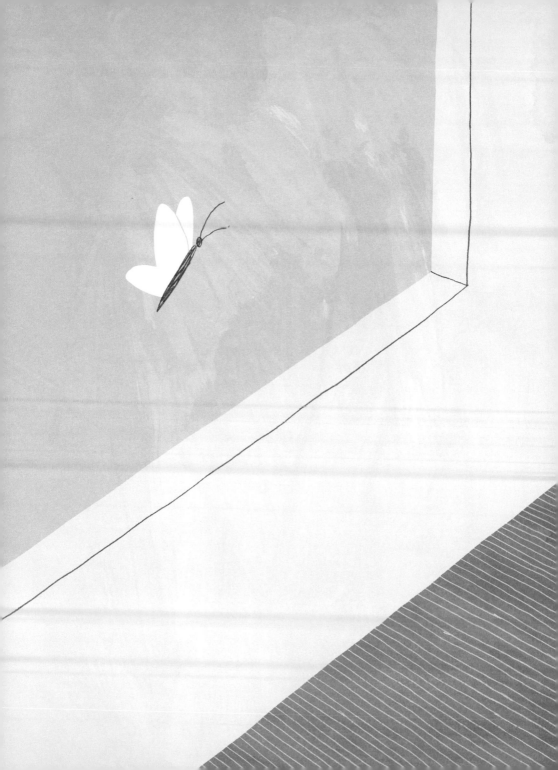

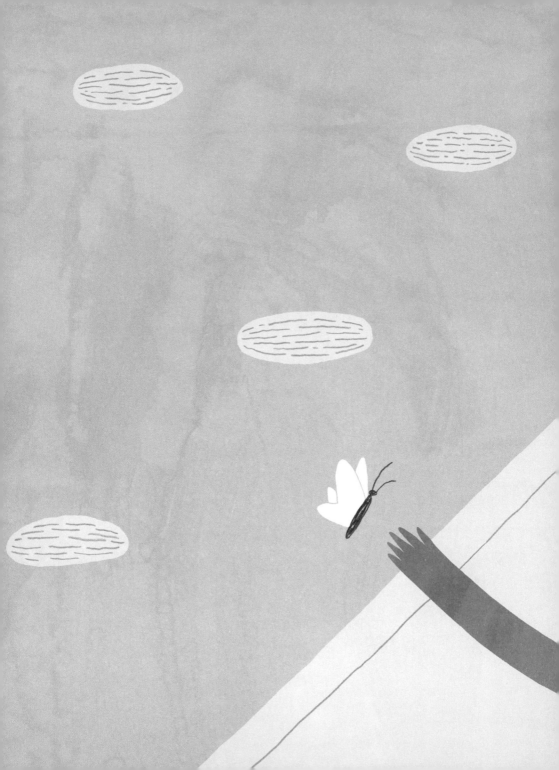

fluttered, danced

and landed on her finger.

The wings were white.

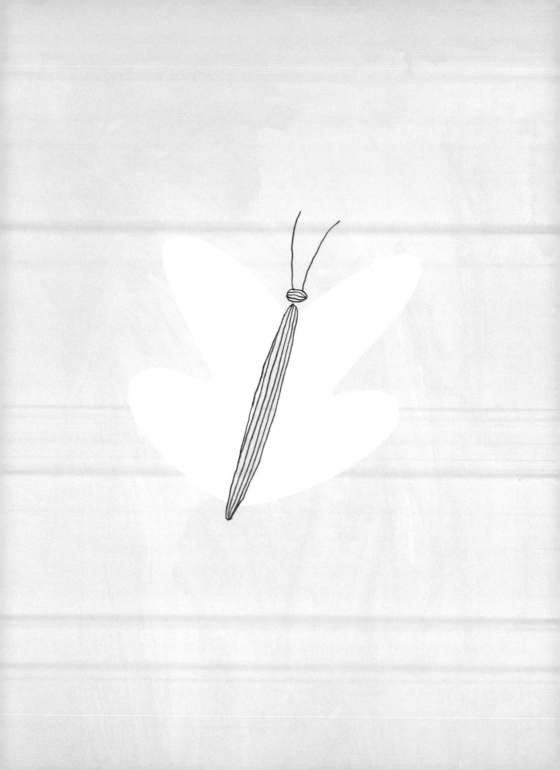

All white.

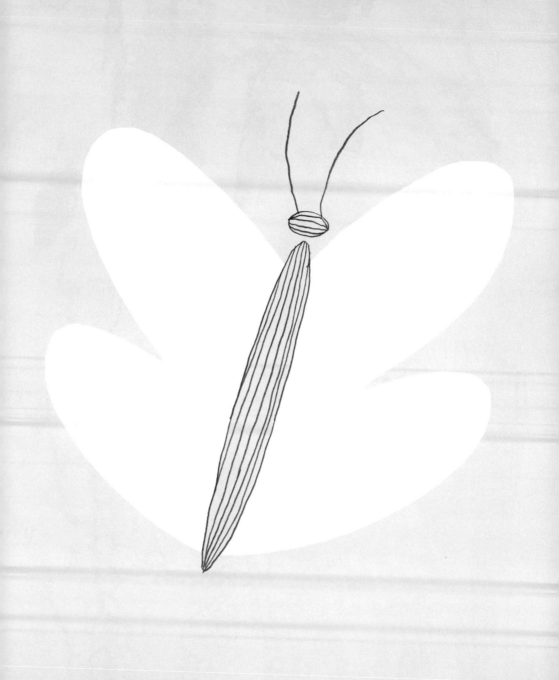

Only light.

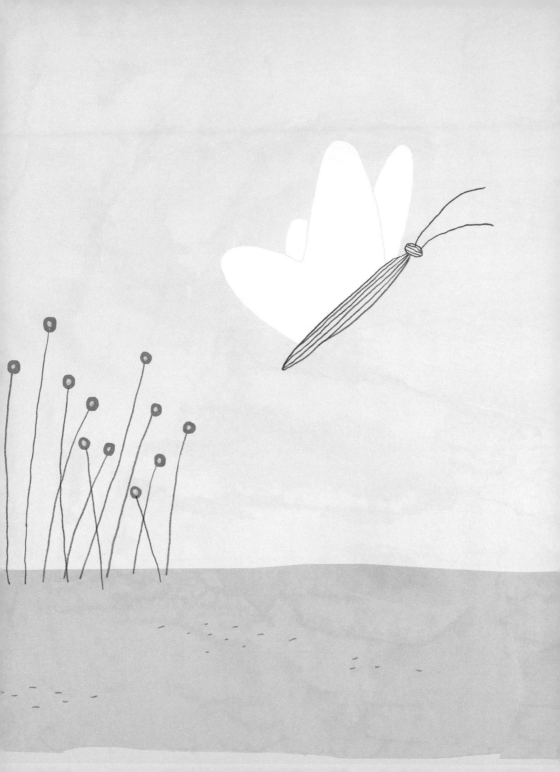

She looked closer.

LOVE

What she saw.
What she remembered.
To take with her, into the day.

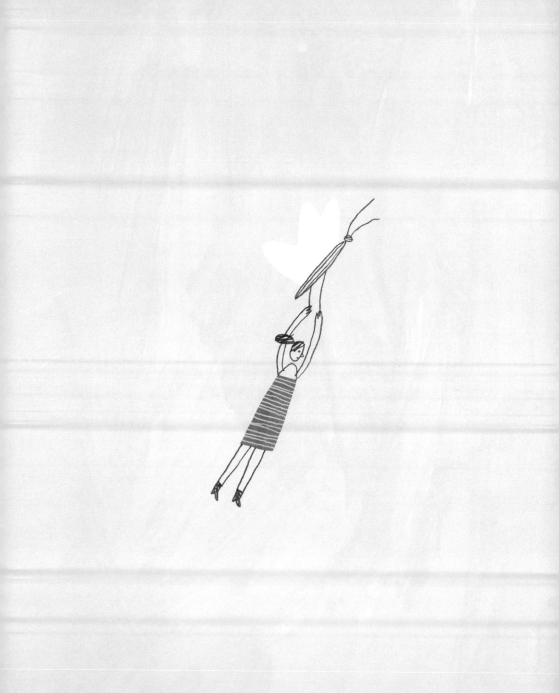

ABOUT THE TYPE

This text is set in Harriet Series, a rational serif type-face designed by Jackson Cavanaugh in Chicago, Illinois, for Okay Type. Inspired by design popular in the mid-twentieth-century, Harriet draws from both transitional faces, such as Baskerville, and modern faces, like Century. At the same time, it is unburdened by these historic models, adopting contemporary features and finish.